MEDIEVAL WARFARE

in Manuscripts

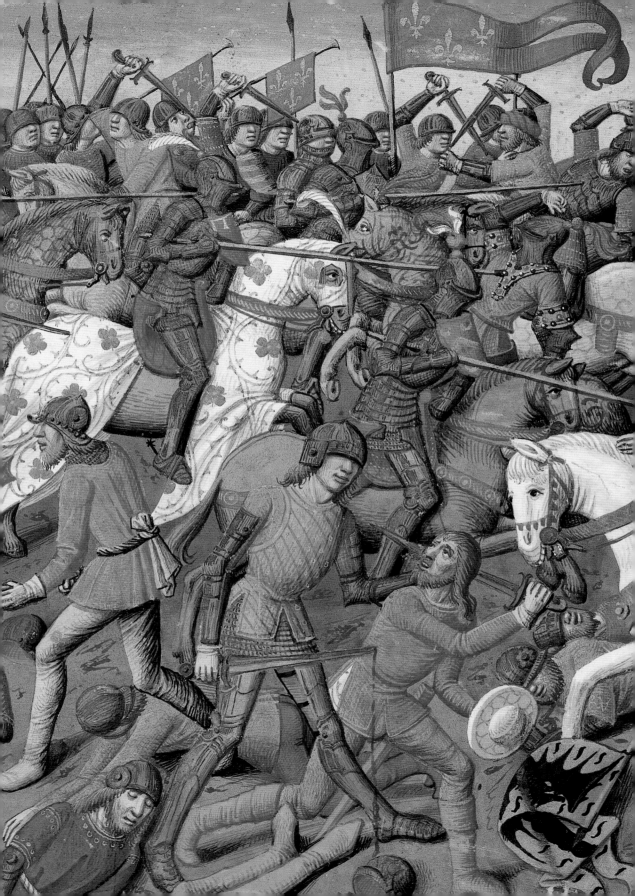

MEDIEVAL WARFARE
in Manuscripts

PAMELA PORTER

UNIVERSITY OF TORONTO PRESS

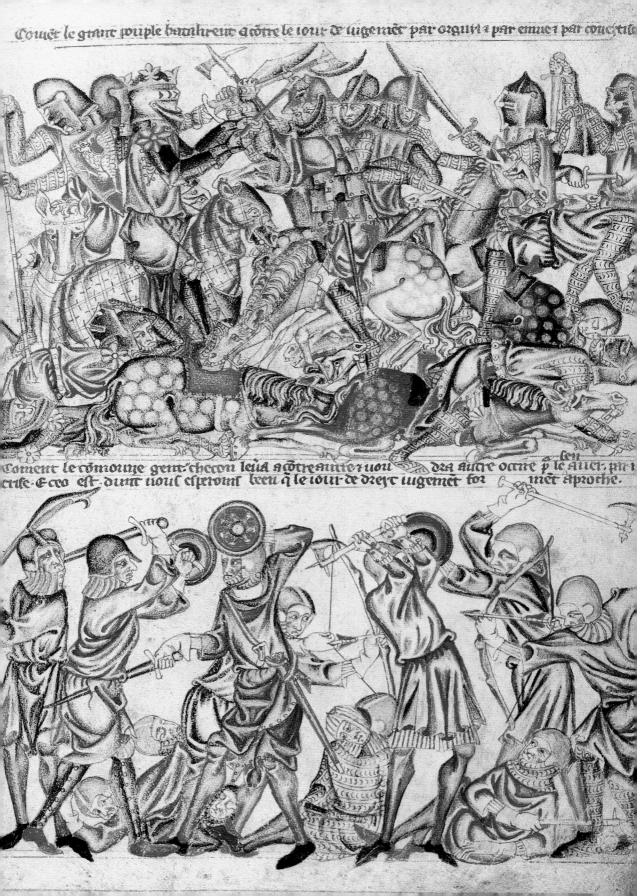

Coment le comoine gem checon leia acotremnnez uou dra sucre ocine p le auer pu
trise E ceo est durnt nous esperoms been q le iour de dreit iugemet for met aproche.

INTRODUCTION

The ways of war in the Middle Ages never cease to exert a fascination. The glamour associated with knights in shining armour, colourful tournaments and heroic deeds appeals strongly to the modern imagination, while the technical ingenuity of mighty war engines provides a constant source of wonder and admiration. Thanks to extensive exploitation of this image medieval warfare has left something of a colourful impression, making it relatively easy to overlook the fact that war in the Middle Ages must have been no less harsh and repugnant a business than it is today. Attitudes have changed, however. Nowadays war is regarded as an exceptional and undesirable event in the course of daily life, but in the Middle Ages warfare played a prominent, if not to say dominant, role in the pattern of everyday existence. Brute force was considered the legitimate way of resolving almost any dispute, and military power was employed not only in major conflicts between countries, but also to settle an endless succession of personal and local quarrels - so much so, in fact, that in medieval times warfare was a profession for the upper classes, and the divisions of society were reflected almost as much in the practice of war as they were in the possession of land.

Over time metal corrodes and wood decays, with the result that comparatively few pieces of military dress and equipment have survived to provide direct insight into the way that war was waged in the Middle Ages. For a comprehensive view of the nature of medieval warfare we have to rely on written documentation and the information preserved in paintings, sculptures, carvings and other pictorial sources. Of these the most numerous by far are the miniatures and drawings found in manuscript books, partly because books tended to survive better than other artefacts by virtue of their sheltered life on library shelves away from the rigours of everyday exposure, and partly because many individual volumes contain multiple representations.

The miniatures in medieval manuscripts, often extremely evocative, create the impression of giving a 'snapshot' view of what it was actually like to engage in warfare in

Opposite: Knights and foot soldiers engage in battle, c.1327-1335. Add. MS 47682, f.40

the Middle Ages. In so doing they offer a potentially rich source of information about military dress, equipment and practices, but it must be remembered that they should be treated with a certain amount of caution as sources of accurate information. Certainly they portray medieval warfare through contemporary eyes, but we must constantly bear in mind that medieval book illustrators did not set out to provide documentary evidence for future generations. Their representations may be recognisable, but in the absence of supporting documentary or other evidence it is frequently impossible to know whether the items depicted reflect a degree of accurate knowledge or simply the artist's powers of invention or skills as a copyist. Moreover, medieval illuminators do not show the same concern for historical accuracy that we might expect from a modern book illustrator, so well-documented events such as the Battle of Hastings are usually portrayed in contemporary rather than historical terms, which can be misleading. These points notwithstanding the depictions in medieval miniatures, taken as a whole, are still an extremely important source for tracing the broad development of military equipment and practices throughout the Middle Ages.

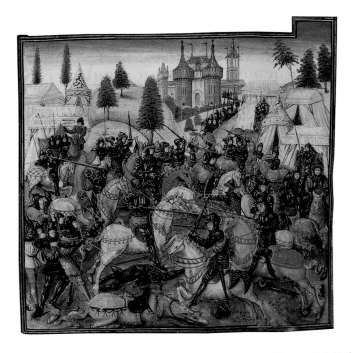

Above and opposite: The Battle of Hastings, portrayed in the late fifteenth century. Yates Thompson MS 33, f. 160v.

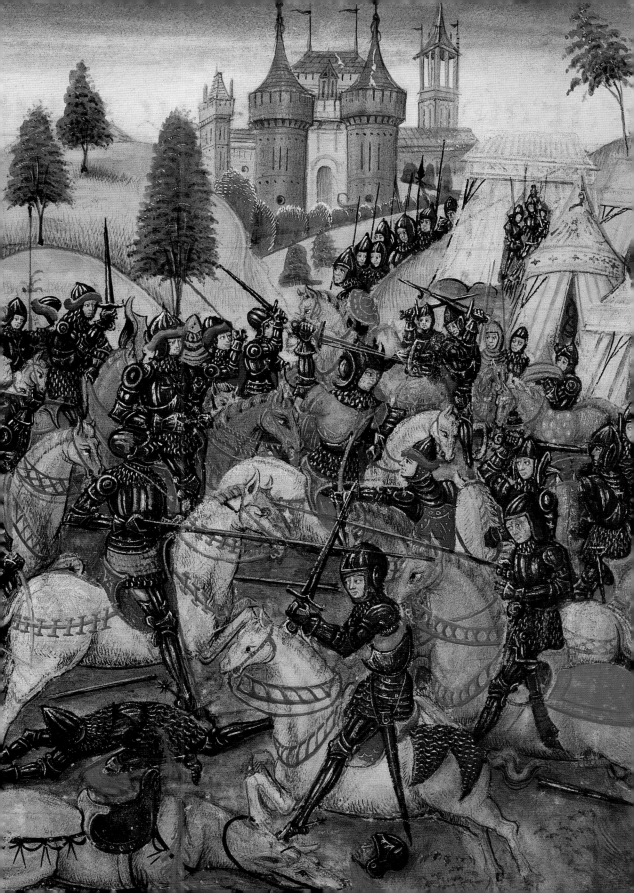

THE ART OF WAR

Rules for the preparation and conduct of warfare in medieval times were guided chiefly by theories inherited from Graeco-Roman Antiquity. Classical manuals of military science, containing detailed technical instructions in matters of siegecraft, the construction of war machines, strategy, tactics, and the training of troops, were full of theoretical concepts and applied mechanics which depended heavily on accompanying visual aids for a full understanding of the texts that they contained. We have no information about manuscripts written in the intervening years, but Byzantine manuscripts written in Greek in the early Middle Ages maintained a continuity with this classical tradition, providing examples of the interdependence of illustration and text. Comparatively few of these earlier Byzantine manuscripts have survived but our knowledge of them is extended by sixteenth-century copies, made at a time when interest in military theory was enjoying a considerable revival. One such copy, produced in Northern Italy, is known to be a faithful reproduction of an eleventh-century Greek manuscript which did survive and is now in the Vatican Library. A manual on poliorcetics or siegecraft by a tenth-century writer known as Hero of Byzantium, it is essentially a compilation of material derived from earlier Greek writers and modernised by the author with the aim of making it user-friendly for a non-specialist public. In keeping with classical models it contains a large number of extremely detailed 'technical' illustrations to assist the reader's understanding of the complicated techniques and equipment of siegecraft described in the text. For example, a detailed account of a mobile siege tower which can be moved in any direction is accompanied by an illustration showing an eight-wheeled penthouse with a ram suspended by strong ropes from its structure (opposite). The battering end is equipped with a crossbeam bearing a net to be used for scaling walls, while an enclosed area above provides a shelter for observing the defensive measures of the enemy within the fortress. The entire structure is massive in proportion to the accompanying figures, consistent with the textual comment that it requires a hundred men to move it on account of its weight. The number of illustrations

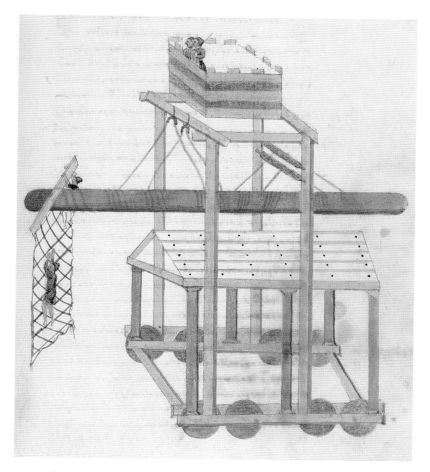

Drawing of a siege tower as a visual aid. Eleventh century, copied in sixteenth century.
Add. MS 15276, f 12

and the scrupulous attention to detail in such books, of which many were produced in the eastern Mediterranean area during the early Middle Ages, give the impression that they were intended primarily for study rather than for immediate practical consultation.

By contrast, the classical tradition of applied illustration seems to have died out completely in the west, perhaps all the more surprising because military thinking in Europe was dominated by the work of Flavius Vegetius Renatus, a high-ranking official of the fourth century AD. His *De re militari* was widely copied, translated and adapted, as witnessed by the fact that over 300 medieval manuscripts of the work survive, without doubt a mere fraction of the total number actually made. Although outdated in many respects the work included a chapter on siegecraft, a skill vital for the success of many medieval campaigns,

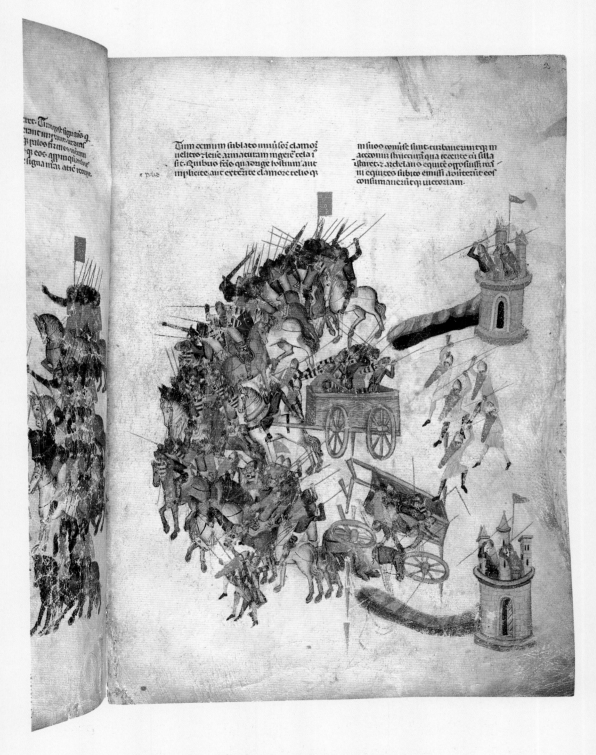

Sulla's defences against scythe-bearing chariots, late fourteenth century. Add MS 44985, f.2

and its presence in many royal and noble libraries indicates that it was probably required reading for military commanders. As well as luxury copies made for libraries there are still in existence some manuscripts in a portable, compact format, so the work may also have been regarded as useful for reading or consultation while on campaign. Whatever the format, however, Vegetius manuscripts do not normally contain explanatory visual aids that relate to the text. Such illustrations as occur – and they are by no means universal – are typically presentation miniatures or appropriate generalised subjects such as knights in combat or siege scenes.

Vegetius cites as one of his sources a treatise on military science, later lost, compiled by another author popular in the Middle Ages, although of considerably less importance if the number of surviving manuscripts can be taken as evidence. Sextus Julius Frontinus, a Roman soldier and author who lived from about AD 40 to 103, compiled a collection of military stratagems from Greek and Roman history, presumably as concrete examples to supplement his theoretical manual. The lasting value of specific situations to explain the finer points of military theory very probably accounts for continuing interest in this practical work of Frontinus beside the more abstract work of Vegetius. Surviving medieval copies of the *Strategemata* resemble those of the *De re militari* in that they may be decorated or illustrated with conventional miniatures but do not have technical illustrations. One exception is known, however. The British Library possesses nine leaves from a manuscript made in Italy some time in the late fourteenth century, consisting of a remarkable series of detailed and lively coloured drawings which occupy about two-thirds of each page below the brief sections of text to which the illustrations relate (opposite). Very individual in style, the drawings supplement the text in exactly the same way as the technical illustrations of classical antiquity, suggesting that the volume was either modelled on an earlier manuscript or deliberately made to reproduce the antique style. The present location of the remainder of the volume is unknown, if indeed it still survives, and these nine leaves represent only a very small fraction of the whole text. Assuming that the entire manuscript was textually complete and conceived in the same format throughout, it would have been a large, grand and very expensive volume, undoubtedly made for a most important patron.

KNIGHTS, CHIVALRY AND THE TRAINING FOR WAR

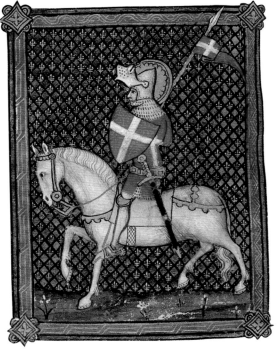

The knight, the professional soldier of the Middle Ages, is probably the medieval figure who more than any other has captured the popular imagination. A full-page miniature of St. Maurice in a late fourteenth-century French Book of Hours depicts just the type of image on which the popular knightly stereotype is based – a mounted warrior in full armour, equipped with sword and shield and carrying a lance with a pennon. Full military trappings are an essential feature of the knight's outward appearance, but they are less likely to account for his intrinsic appeal than the romantic image promoted by his association with the medieval world of chivalry and all its attendant pageantry.

St. Maurice as a late fourteenth-century knight. Add. MS 23145, f. 37v.

Chivalry was the word used to describe an elaborate code of conduct which determined knightly behaviour. The name came from the French word for mastery of the horse, perhaps the chief skill that a young knight acquired when he received his early training in the arts of war. Although not always strictly followed, the rules of chivalry represented the highest military, courtly and religious ideals. A knight was expected to be valiant in battle and magnanimous in victory, gentle in manners, generous, truthful and just. It was also his duty to protect women, and to show undying devotion to his lady.

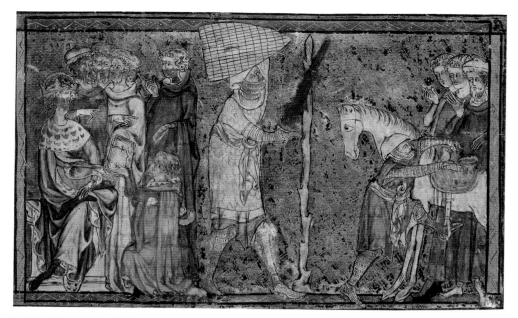

Training for knighthood and military service, early fourteenth century. Royal MS 20 B XI, f. 3

Knights came from a particular social class, training for knighthood starting at an early age when a boy was sent to court to serve as a page. Here he began to acquire some of the skills essential for his later role, in particular those involved in mastering horsemanship. Serious military training started at the age of fourteen, when as a squire he carried his knight's shield, accompanied him to battle, assisted him in putting on his armour and cared for his weapons and horses. A squire also received regular training for arms and combat.

One illustration to a manuscript of Vegetius, whose first chapter deals with the training of recruits, shows a young squire fighting at the 'pile' or 'pale', a device employed to teach the use of the sword and shield during combat on foot (above). The 'pile' sometimes took the form of a Turk or Saracen, but here we find the more usual plain pole, about 6 feet high, firmly fixed in the ground and with notches placed to indicate the head, arms and other vulnerable parts of the opponent's body. Another figure in the same miniature is practising the difficult task of mounting a horse when fully armed, a skill that was of vital importance for a mounted warrior.

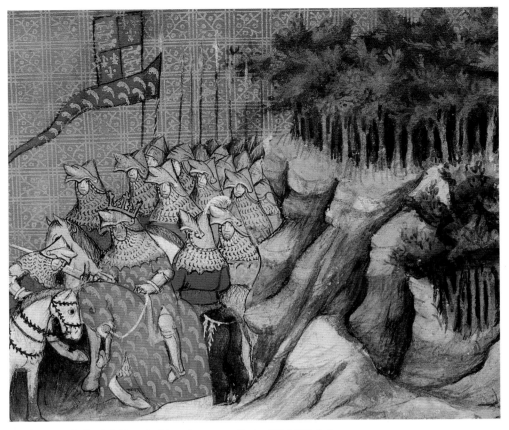

Knighting on the battlefield, early fifteenth century. Harley MS 1319, f. 5

Before leading an army into battle the squire had to be knighted, a ceremony which for reasons of expediency might take place on campaign as shown in a miniature illustrating an account of the life of Richard II (above). Normally however the ceremony occurred when the squire was twenty-one, as long as he had demonstrated his worthiness to receive the two most potent symbols of knighthood, a sword and spurs. A simple ceremony of giving weapons to the new knight gradually became more elaborate and solemn under the influence of the church, involving a ritual bath to symbolise purification, a night of vigil and prayer and the blessing of his sword before it was given to the sponsor to whom he made his knightly vow. Sometimes the presentation of weapons was accompanied by the accolade, a symbolic blow on the shoulder with the flat of the sponsor's sword. At last the knight was ready to play his full part in war and all its related activities.

Much of the pageantry of medieval courtly life was associated with a pastime which gave the knight invaluable training and practice for the field of battle. The tournament was an entertaining spectator sport in which two teams of knights fought each other in friendly contest to win honour and renown. In the tournament proper or mêlée two teams of knights fought a mock battle according to an agreed set of rules, while a joust – frequently included as part of the programme – was an individual encounter which enabled two knights to display their military skills to best

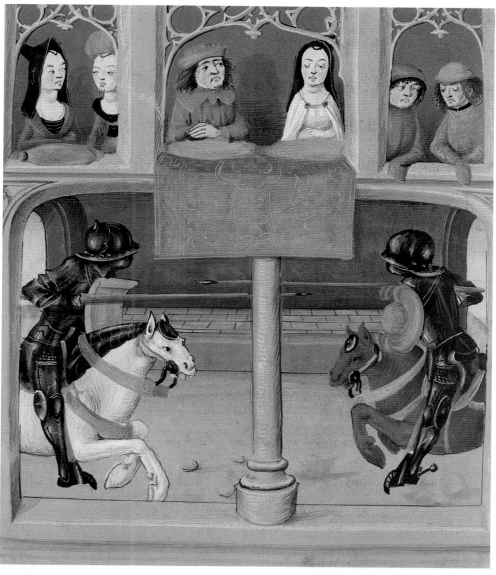

A joust between two knights, late fifteenth century. Royal MS 14 E IV, f. 293v

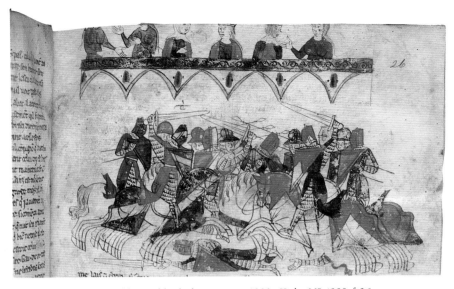

An early tournament, more like a real battle than a sport, c. 1300. Harley MS 4389, f. 26.

advantage. Although the object of the sport was friendly, at least in theory, many early tournaments were rough affairs involving indiscriminate mass combat, often leading to death and injury (above). Later tournaments became more controlled (below), perhaps because the presence of ladies among the spectators exerted a civilising effect on the proceedings. Sometimes the rules allowed the victors to demand ransoms, arranged beforehand, or to capture horses, arms and armour from vanquished opponents, as might happen in reality on the battlefield. At the end of the day there was usually a prize, presented by a lady, for the knight who performed best (opposite).

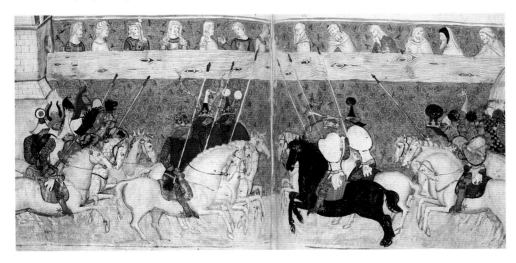

A later tournament organised by stricter rules, c. 1352. Add. MS 12228, ff. 157v-158

Gradually the reduction of physical risk to participants was emphasised to such a degree with the development of specialised armour and the introduction of safety features like tilt barriers, that by the end of the fifteenth century the medieval tournament with all its skill and excitement had been transformed into little more than a theatrical spectacle. By then, however, the nature of warfare was changing so significantly with the introduction of new weapons and skills, that the role of the knight on the battlefield was already in decline.

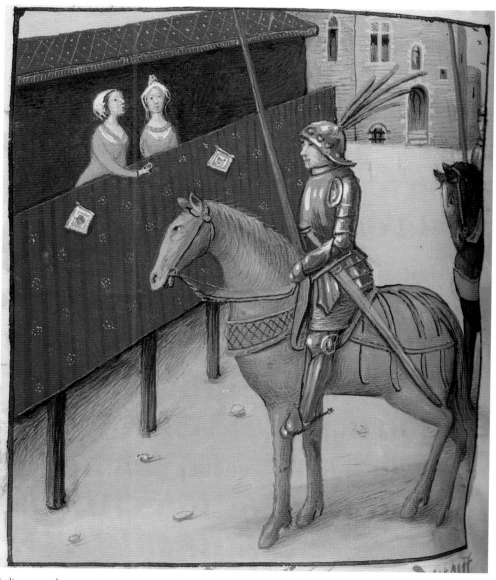

Ladies present the tournament prize to a victorious knight, late fifteenth century. Royal MS 19 E II, f. 129v.

KNIGHTLY ARMS AND ARMOUR

From the Norman Conquest onwards weapons and basic equipment remained essentially the same, but the appearance of the knight changed in certain distinctive ways as attempts were made to improve the protective qualities of body armour, helmets and shields. Miniatures in manuscripts allow us to document the broad sequence of development but we must be cautious when making specific interpretations. On the factual side there is the difficulty of identifying a 'typical' knight at any one point in time. Responsible for the provision of his own armour, a knight would have considered practical factors such as cost and availability – hard-wearing armour was often handed down within families – so that a wide variety of types and styles could be found side by side at any one time. With regard to the illustrations we need to bear in mind that artists were not necessarily recording accurate information either about the armour of their own day or about armour in general, that they may sometimes have been following certain artistic conventions that we do not understand, and that a vast amount of copying took place from one source to another. The portrayal of the forged or riveted metal rings used in the making of mail armour provides a good example of the problems. A number of different techniques were used to convey the linking process, implying the existence of a corresponding variety of patterns, but surviving pieces of mail totally fail to corroborate this. It is quite possible therefore that artists were following some sort of convention, or simply finding a way of distinguishing between different groups of warriors or types of armour. In some cases, of course, it may be that the artist, familiar with the appearance of mail but unfamiliar with its construction, was merely using his creative imagination.

Until the eleventh century, warriors wore everyday clothes with shields for protection, their leaders sometimes adding a helmet and short mail shirt, but a mounted knight needed better bodily defence. On horseback it was not only awkward to manoeuvre a shield, but an opponent's weight combined with the speed

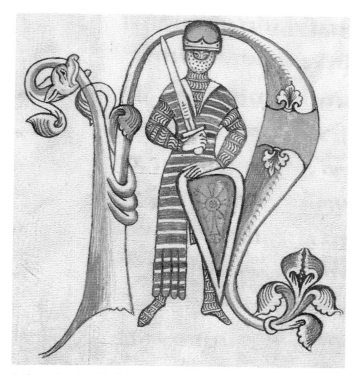

Knight in a long-sleeved hauberk under a flowing gown, twelfth-thirteenth century.
Add MS 39645, f.72v

of his horse greatly increased the force of any blow. Consequently the mounted knight differed from his predecessors in wearing a mail shirt and protective mail coverings for the limbs, and a helmet became the norm. The mail shirt or hauberk reached down to the mid thigh with a slit up the fork of the legs to accommodate the saddle. Worn over a thin gown the hauberk, with a few refinements, remained the main body defence throughout the twelfth century, but in later years the knight's appearance took on a new look with the introduction of a long loose gown worn over the armour (above). A thirteenth-century illustration to a 'Chanson' relating to the wars of Charlemagne (page 20) shows how a tight-fitting mail hood known as a coif was made as one with the hauberk to protect the head, while by this time mail 'mittens', slit to free the hand for normal use when not in combat, had appeared on the ends of the sleeves.

Flexible enough for relative freedom of movement and effective against sword cuts, mail must have chafed the skin even with an undershirt, and it offered only minimal protection against heavy blows. Foot-soldiers, normally unable to afford

mail, wore more homespun protection in the form of a quilted tunic fashioned from two pieces of material padded with wool, cotton or rags. Known as a gambeson or aketon, this garment was difficult to pierce and remarkably effective in deadening a blow. From the early thirteenth century onwards the well-equipped knight added a similar quilted garment as a shock absorber under his hauberk, a safety feature which also added greatly to his comfort. Some warriors wore garments with protection for the upper part of the body in the form of overlapping riveted plates – a type of scale armour, usually worn as an alternative to mail and particularly popular in the thirteenth century. Iron or horn plates, either rectangular or with rounded ends, were attached to a cloth or leather garment, overlapping to make a firm surface which would resist blows, sword thrusts and the piercing of arrows.

The drawbacks of mail as a protective covering eventually began to be more obvious, especially when knights had to contend with the effects of the longbow (see page 32). Even when doubled for extra strength, mail broke easily and was liable to be pierced by arrows travelling at speed, not to mention being prone to rust and difficult to clean. Initially protection was improved by adding metal plate or hardened leather to shield vulnerable parts of the body, at first just the knees and

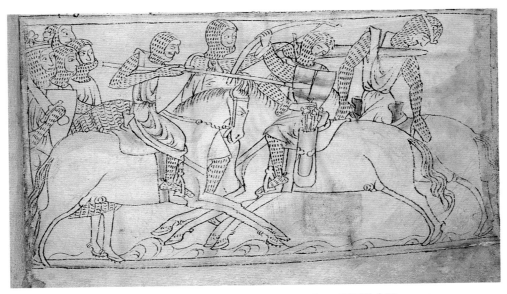

Mail-clad knights, and the rare sight of a mounted archer, 1225-1250. Lansdowne MS 782, f. 10.

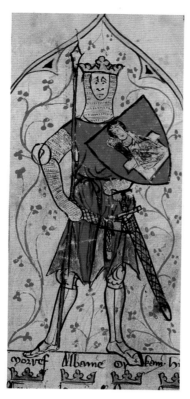

King Arthur portrayed in contemporary armour, 1300-1325. Royal MS 20 A II, f. 4

elbows, but subsequently the legs as well. In an early fourteenth-century manuscript King Arthur is depicted as a contemporary mail-clad knight with solid plate defences on his elbows, knees and lower limbs above. By about 1325 elbow-guards, greaves – the gutter-shaped plates defending the shins – and knee cops were all to be found in common use.

Solid metal plate offered far better protection than mail; virtually impenetrable by arrows or sword points, it could also spread the force of a heavy blow. Soon solid breastplates began to appear under or over the hauberk, at first made of hardened leather, but later of iron. In some cases the mail hauberk was supplemented by a form of body armour known as a pair of plates, consisting of a fabric or leather garment lined with overlapping pieces of metal, rather like a scale hauberk turned inside out. Where the breast section was a single plate, the skirt either retained the pair of plates construction or was made of narrow horizontal hoops allowing the wearer flexibility to bend. By this time reinforcing plates on the limbs

had spread to include the upper arms, forearms, shoulders and thighs, while a series of small overlapping plates protected the front of the foot, and scale reinforcements were added to the mail gauntlets which superseded the earlier mittens. The appearance of the knight was completed by a short, sleeveless surcoat, more practical for combat than the long flowing garment previously worn, and suitable for displaying the wearer's heraldic arms (see page 29).

By the early fifteenth century plate defences were completed by the introduction of a backplate to match the breastplate, causing the surcoat to go out of fashion. Gauntlets were strengthened by the addition of metal strips to protect cuffs and fingers, while elegant pointed steel shoes had a single plate enclosing the heel at the back and a series of overlapping narrow metal bands for flexibility at the front. Defensive armour had now reached a point at which the wearer could rely almost totally on an outfit made of hinged and riveted plates for protection (page 28),

Crusaders in mail armour go to war, early fourteenth century. Eg. MS 1500, f 46

further developments being mere modifications to maximise efficiency. Plates were made larger so that fewer were necessary and, thanks to the constantly improving skills of the armourers, better shaping and closer fitting offered maximum resistance to missiles and blows. By the end of the century the defensive quality of body armour had reached the point at which no further improvement was possible without making armour so heavy that mobility would be seriously impeded.

The helmet, standard equipment for a mounted warrior, was worn either as a reinforcement for the mail coif or on its own. Early helmets were conical, sometimes with a bar riveted onto the rim as a nose-guard, a feature still in evidence in the thirteenth century. The soldier portrayed on page 19 wears a simple round-topped helmet of a type appearing towards the end of the twelfth century, at the same time as a new flat-topped style that was to develop into the characteristic all-enclosing helm of the thirteenth century. Deep and more or less completely cylindrical in form, it often

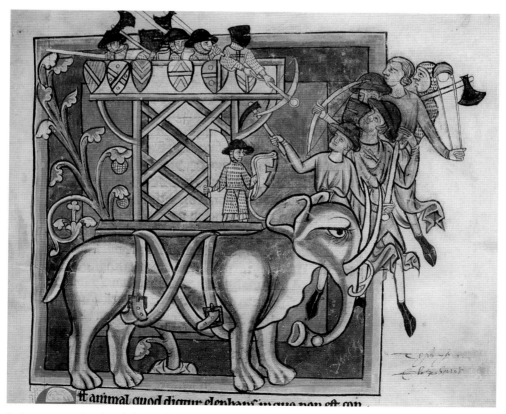

Bestiary representation of an elephant used as a siege tower with two defenders wearing all-enclosing helms, 1230-1240. Harley MS 4751, f. 8

curved in towards the throat at the front. Reinforced 'sights' or slits were provided for the eyes, and small holes at the lower part of the front allowed the wearer to breathe. Although of formidable appearance its flat top was a natural target for heavy blows which could stun the wearer, and by the end of the century the shape had again become conical to create a glancing surface that would deflect heavy blows rather than absorbing them.

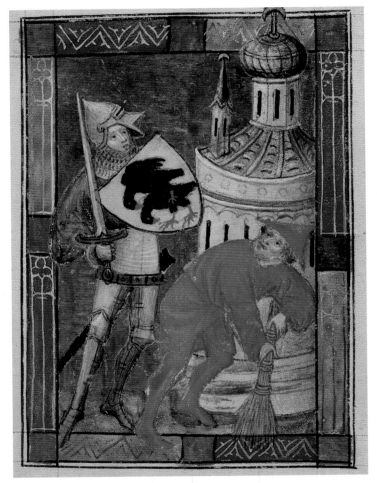

Front view of plate defences for the legs, and visored helmet, c. 1405. King's MS 5, f. 7

Even with eye-slits an all-enclosing helm would have impaired vision, so from the fourteenth century the section covering the face was given pivots to allow it to be raised for a better view or when combat was not expected. This movable face protector, or visor, was also fitted to a new lightweight helmet known as a bascinet,

developed from the simple rounded steel skull cap worn by many knights throughout the thirteenth century in preference to the cylindrical helm. At first the visored bascinet retained a rounded shape, but soon the top was modified to become conical. The visor had a sharp, pointed swelling over the nose, giving the knight a particularly distinctive appearance (below). At first bascinets were worn over the built-in coif, but later the throat and neck were protected by a tippet or aventail, a miniature mail cape attached to

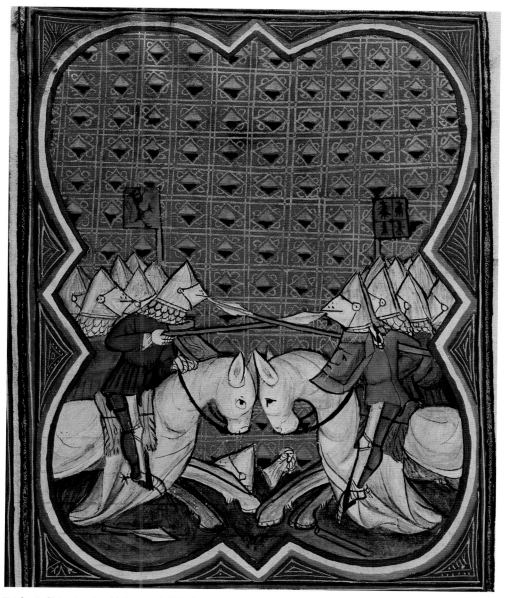

Knights in distinctive visored helmets, end of the fourteenth century. Royal MS 15 D VI, f. 513

the bascinet and sometimes buckled or tied to the body armour to stop sword or lance thrusts from passing underneath it. From an early stage the tippet might also be covered by a plate collar, but with the more widespread use of solid metal protection it was common for two or more gorget plates to be worn over the tippet, fixed in such a way that the lower edge of the visor fell inside their upper edge. Pointed visors could still be found, but a version with a blunt swelling over the nose and mouth became more usual, and helmets were shaped to fit the contours of the head, giving them a more rounded appearance.

Rear view of plate protection for the legs, and a form of kettle helmet, c. 1405. King's MS 5, f. 7.

Frequently manuscript miniatures depict warriors in helmets with a rounded top and narrow brim, strangely reminiscent of modern military wear. Known as 'kettle helmets' on account of their resemblance to an upturned cauldron or medieval 'kettle', they first appeared in the twelfth century and remained popular throughout the Middle Ages. Even when worn over a coif they offered inferior protection in combat by comparison with their enclosed counterparts, but they must have been far more comfortable to wear. Such helmets were also extremely valuable for certain types of siege work such as mining, since vision remained unimpaired and the brim could deflect descending missiles.

The knight's other distinctive feature was his shield. The large round shield which protected the body in earlier times was impractical for mounted combat. A knight on horseback could use his sword to defend his right-hand side,

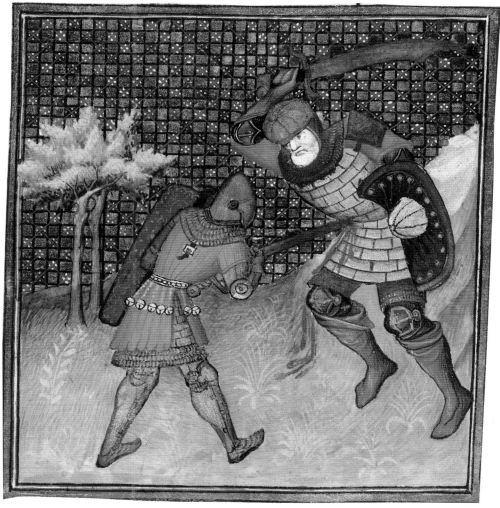

Two warriors protected by scale, mail and plate, c.1415. Cotton MS Nero E ii, part 1, f. 124.

but he might easily be trapped with the entire length of his left-hand side exposed. This led to the introduction of a long kite-shaped curved shield with a rounded top which screened the body and most of the left leg. Such shields, made of leather-covered wood and bound with steel bands, had a strap or 'guige' which went over the neck and round the right shoulder to support the shield fully when not in use and reduce weight on the left arm when needed in action. Later the rounded top became straight, presumably for better vision, and in about 1250 a smaller 'heater-shaped' shield, formed like a downward pointing triangle with curved sides, was introduced. Rapidly increasing in popularity, it remained in use until body armour

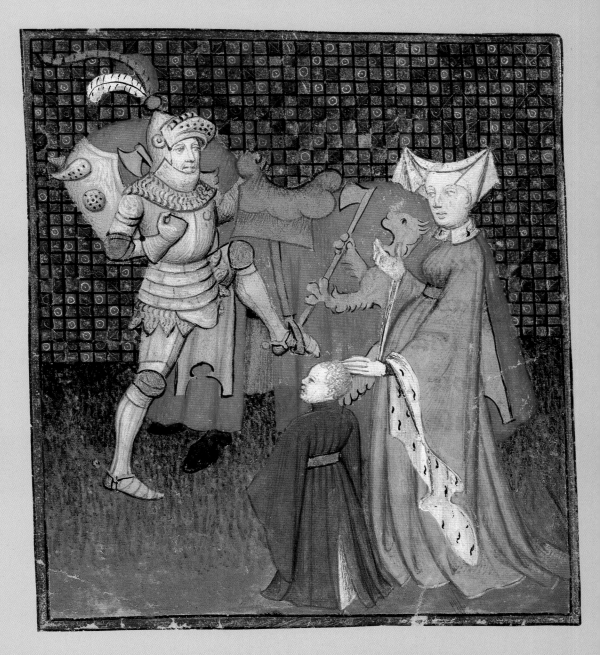

Well-developed plate armour for knight and horse, early fifteenth century. Harley MS 4431, f. 135.

had been strengthened to the point where a shield became an unnecessary encumbrance.

Medieval knights gain some of their colourful reputation from the heraldic devices that they display, heraldry partly owing its origins to the introduction of the face-concealing helm, which made it impossible to distinguish friend from foe in battle. By the mid twelfth century some knights carried shields painted with distinctive devices which were later to reappear on the shields of their sons. From these beginnings an elaborate system of identification developed in which small variations were devised to distinguish younger sons and branches of families. The devices used were generally animals, birds or simple geometric shapes, bold enough to be recognized at a distance. The shield was the most prominent place for heraldic identification, but an armed and mounted knight had other opportunities to display his device. It could be painted on the surcoat worn over the hauberk – hence the term 'coat of arms' – and on the saddle cloth or horse trapper. Armorial devices were also

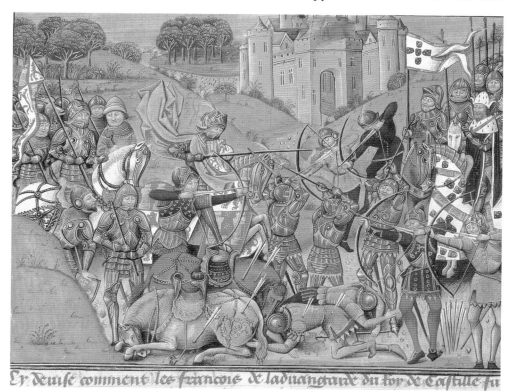

Heraldic shield, pennon and horse-trapper on the battlefield, late fifteenth century. Royal MS 14 E IV, f.201v

displayed on flags. The ordinary knight's flag was a pennon, pointed or swallow-tailed in shape, and carried at the top of his lance. Higher-ranking knights or commanders bore their arms on banners, at first rectangular and attached lengthways along the lance, but later almost square.

The knight's most important piece of fighting equipment was his sword, supplemented by a dagger or other weapons which might contribute towards success in military encounters. He also carried a lance, to be tucked under his arm and used in the charge. Highly prized as a possession passing from father to son in Saxon times, the sword commanded a veneration that acquired a symbolic role in the Middle Ages as a token of knighthood. The early sword had a long, straight two-edged blade with a deep groove down the centre to reduce the weight without weakening the cutting edges. The handle or hilt was separated from the blade by a short protective crossbar, while the grip terminated in a heavy knob or pommel which helped to counteract the weight of the blade. Although modifications were made to deal with improvements in the protective quality of body armour, the basic design of the straight two-edged sword remained unchanged throughout the Middle Ages. At first intended merely for slashing, the blade began to be made longer, slimmer and with a better point so that it could also be used for thrusting. The introduction of solid body armour prompted the appearance of special swords with blades forming a diamond shape in section and tapering to a sharp point, particularly effective both for thrusting between the joints of plate armour and for piercing mail. Many knights carried such a sword in addition to a dual purpose sword for cutting and thrusting. Solid body armour may also account for the introduction of a longer and heavier sword with a deep hilt, which could be wielded with both hands to give greater striking power. Manuscript miniatures from the thirteenth century onwards portray warriors using a falchion, a sword with a broad, cleaver-shaped blade curved at the cutting edge. Generally wider at the end nearest the point, the distribution of weight along the blade gave it exceptional shearing force. Less common than the straight-edged sword, it nevertheless enjoyed a certain amount of popularity.

ARMIES AND BATTLE

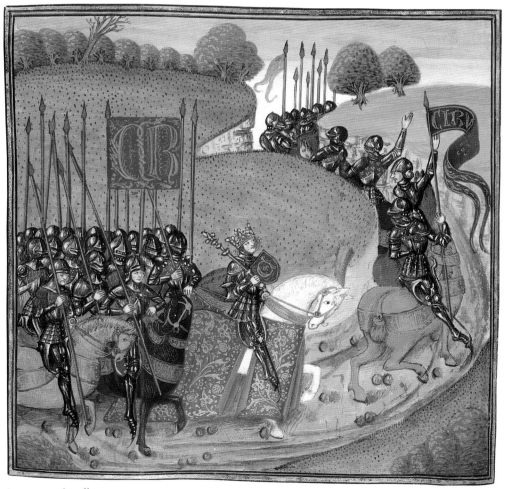

With no concept of a regular army in the Middle Ages, almost any man could find himself involved in military action. Knights, wealthy enough to equip themselves with armour, weapons and a horse, rendered military service in return for the possession of land, while foot-soldiers came from the poorer classes. The only body armour they could afford was usually homemade – a quilted tunic or gambeson – sometimes with a helmet or other piece that they had been lucky enough to find on the battlefield. Frequently they fought with axes, clubs or whatever they could lay hands on to serve as weapons, but

An army marches off to war, c. 1470-1480. Royal MS 16 G IX, f. 42v

their ranks also included the archers, an extremely significant force in military engagements, particularly in the later part of the period.

The longbow, used by foot-soldiers, was a fast-shooting long-range weapon of great impact and importance. Although capable of accuracy if carefully aimed, its chief strength in battle lay in its suitability for massed attack. A volley of arrows fired by a comparatively small body of archers could easily destroy a charge by mounted knights. The longbow first appeared in the English army after Edward I had seen it in action in Wales in the late thirteenth century. It rapidly proved its worth, becoming a decisive factor in many of the battles of the Hundred Years War. The crossbow existed earlier, rising to prominence in the twelfth century. It consisted of a short, heavy bow, powerfully sprung and attached at right angles to a stock which performed the same function as the arm of the longbow archer. Mechanical devices were used to span the bow, which was too stiff and powerful to be spanned by hand (page 37). It was long-range, hard-hitting, efficient and deadly accurate, but slow and cumbersome to use. For a long time regarded as the ideal infantry weapon, it finally lost its superiority when the longbow appeared, mainly because it just could not compete with its rival's rapid rate of fire.

The miniature opposite shows part of a fifteenth-century army on the march with its horse-drawn baggage train. Moving an army from one place to another was a challenging manoeuvre in medieval times, as the country was rough, the roads poor, and accurate maps just did not exist. Wagons frequently hindered the army's progress by breaking down on the uneven terrain, but they were the only means of transporting all the paraphernalia of a fighting force in transit. Although food could sometimes be secured en route by plunder or pillage, there was no alternative but to transport the rest of the equipment in this way.

A large army comprised three main divisions or 'battles', each consisting of cavalry supported by a body of infantry. When marching they adopted the order of van guard, main guard and rear guard, but on the battlefield the divisions were deployed in any formation suitable for the situation in hand. An encounter with the

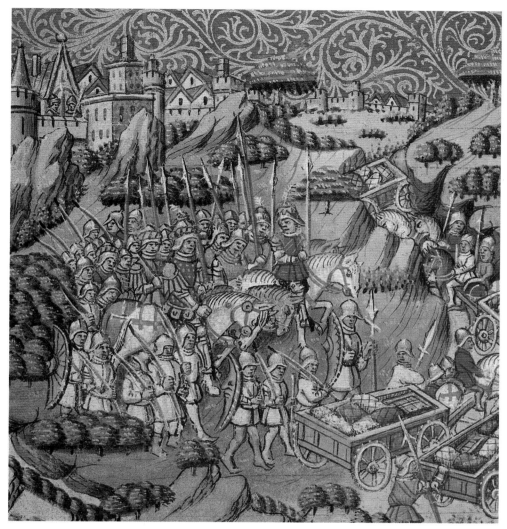

An army on the move with its baggage train, c. 1480. Harley MS 326, f. 90.

enemy might start with preliminary skirmishes of outriders and perhaps some crossbow fire while the armies manoeuvred into position, each hoping to tempt the other into making an impetuous assault with a disastrous outcome for the aggressor. When an attack finally began it took the form of a succession of charges section by section, thus ensuring the continuous application of pressure, even if one group failed and needed to retreat to reorganise. Charges were made by separate units, each containing thirty to forty knights grouped round a leader's flag and using a common battle-cry for mutual encouragement in the assault. Although medieval battles now

conjure up images of colourful banners, spirited charges and deeds of bravery, the lack of discipline in most medieval armies undoubtedly led to a great deal of brutality and bloodshed.

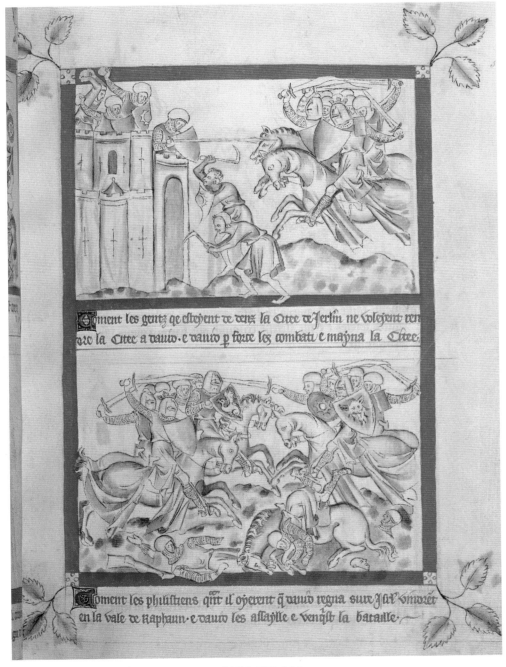

Siege and battle scenes, early fourteenth century. Royal MS 2 B VII, f. 56.

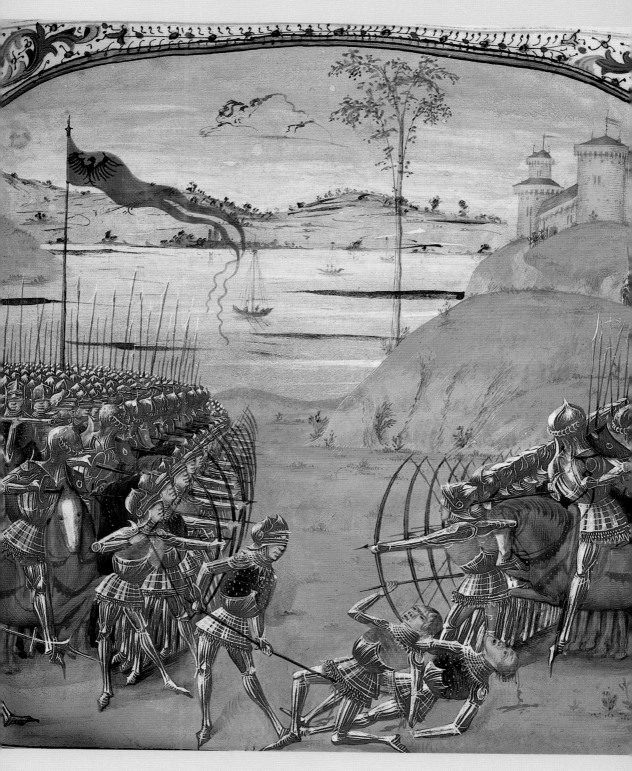

Archers in the front line, 1473. Royal MS 16 G VIII, f. 189.

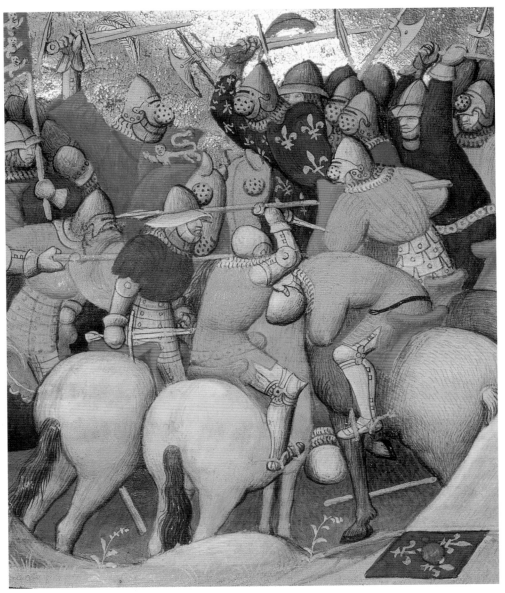

A fatal encounter on the battlefield, c. 1415. Cotton MS Nero E ii, part 2, f. 152v.

Battles would have been extremely noisy with the thudding of horses' hooves, the clash of weapons and armour, the whirring of arrows and the shouts of the participants. A battle-cry was probably distinguishable amid the general uproar, but reliable comprehension of a leader's verbal commands would have been impossible. The need for an alternative means of transmitting orders led to the

Opposite page: Spanning a crossbow during a siege, c.1415. Cotton MS Nero E ii, part 2, f. 1.

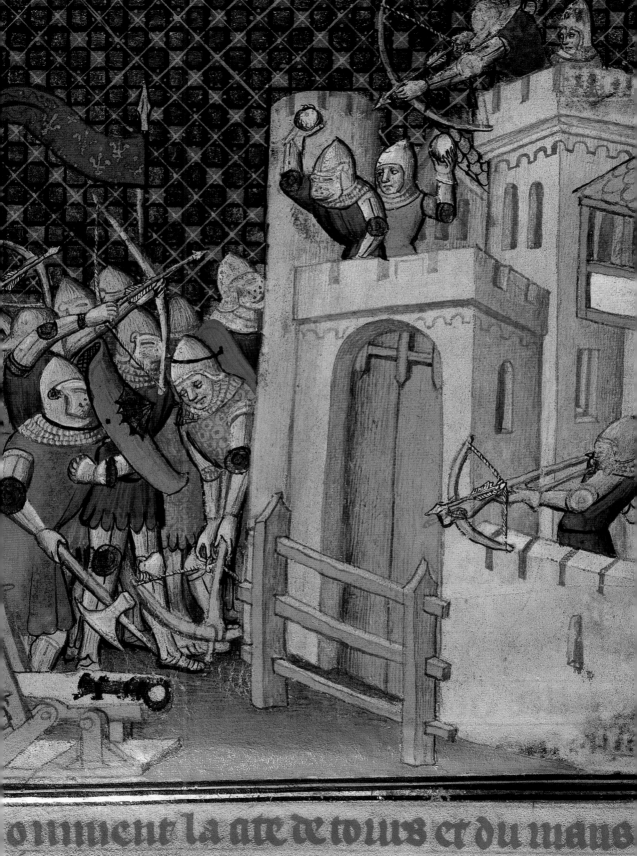

oumient la ate de tours et du maus
un fee et vius et la mort le roi he

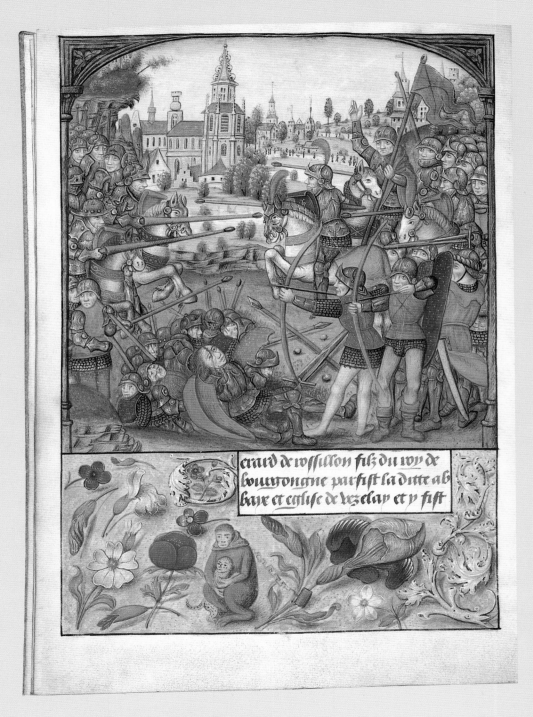

A victorious army advances, c. 1500. Yates Thompson MS 32, f. 7v

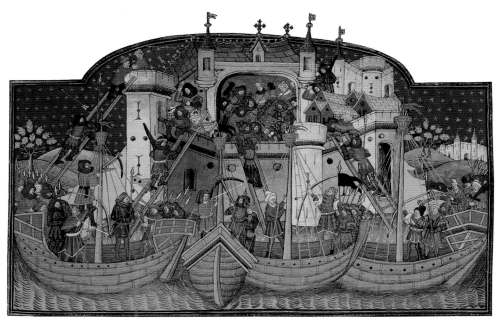

Ships besieging a seaport, 1445. Royal MS 15 E VI, f. 207.

development of military music, nowadays an activity in itself, but formerly a vital element of battlefield action. Various instruments – horns, pipes, drums and particularly trumpets – were employed to produce melodic calls to indicate commands or identify centres of resistance, as well as generally intimidating the enemy with their noise. The trumpeters shown on page 58 wear armour, but many miniatures depict musicians as unarmed, even when performing at the heart of the action.

Purpose-built fighting ships were unknown in the Middle Ages. In times of war fishing craft and merchant vessels were organised into fleets, and every sailor had to become a soldier when the need arose. Although not designed for fighting, a medieval ship might be converted into a 'man-of-war' by erecting wooden towers at each end and fastening a fighting top, a structure sometimes resembling a large barrel, at the highest point of the mast to serve as an observation post or provide height for the archers. The miniature above shows four converted vessels attacking a seaport, while on page 40 two ships engage in a military encounter on the open sea.

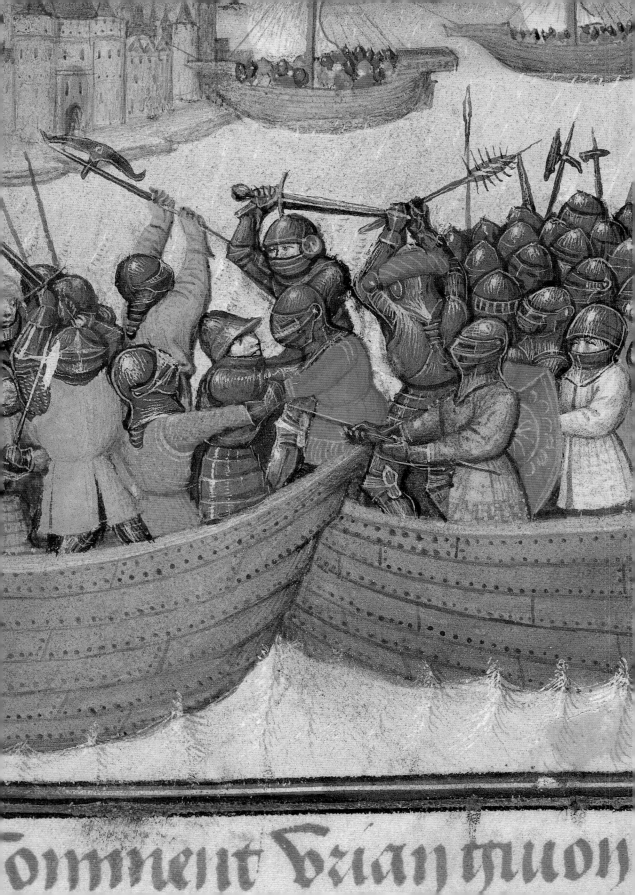

In a naval battle two ships came as close together as possible, allowing the occupants to fire arrows at their opponents and attempt to board the enemy vessel, a grappling hook being carried for this purpose. Once aboard they engaged in hand-to-hand combat (an undertaking fraught with danger in itself because of the confined space) until one side had overpowered the other. The outcome decided, the victors threw their opponents overboard unless they were important enough to command a ransom.

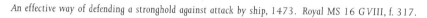

An effective way of defending a stronghold against attack by ship, 1473. Royal MS 16 G VIII, f. 317.

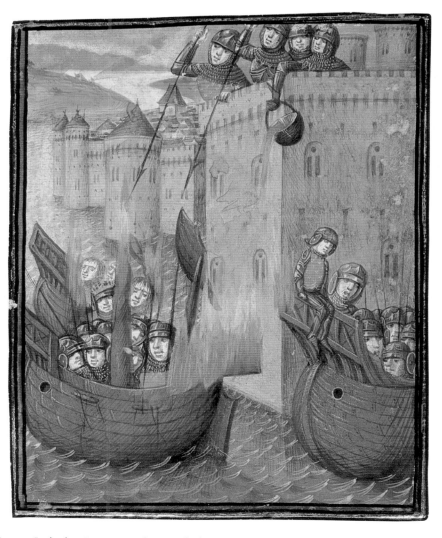

Opposite page: Sea battle, using a variety of weapons for fighting on foot, fifteenth century. Harley MS 4418, f. 80v.

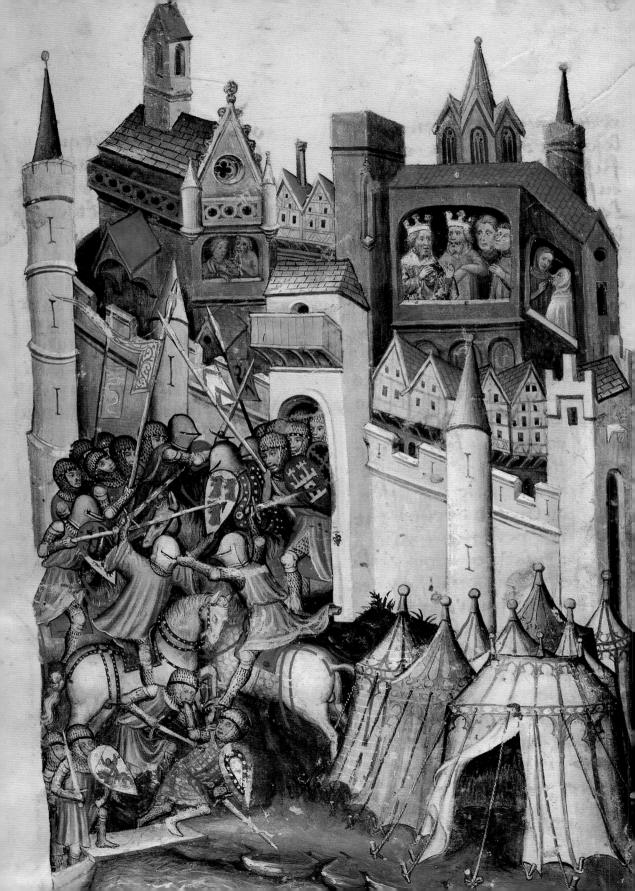

CASTLES AND SIEGES

Pitched battles and skirmishes in the open field were less frequent than sieges because they were likely to be more costly in terms of loss of men and equipment. In addition, armies were expensive to maintain, and there were the difficulties involved in moving a body of soldiers from one place to another. A far less risky campaign could be conducted by undertaking a succession of sieges to capture enemy strongholds which controlled the countryside around them, and siegecraft skills were an essential requirement for every military commander.

Development in styles of military architecture in the Middle Ages owed much to progress in the field of ballistics and other forms of attack; the more efficient the weapons and methods used in sieges, the more modifications to strongholds were necessary to resist them. Assaults might involve towns and cities, generally fortified with walls and other defensive features like the moat in on page 59, but siege warfare was particularly associated with the castle, an important feature of the feudal system in Europe which reached England with William the Conqueror. Although designed as a fortress, the castle was also the residence of its lord and symbolised his wealth and power.

Early timber castles were built on a flat-topped mound of earth (the motte), connected to an enclosure (the bailey), the whole site being protected by a system of deep ditches and earthen ramparts surmounted by wooden palisades. This general plan remained, but fire-resistant stone soon replaced the timber structures. The rectangular stone keep, a distinctive feature of eleventh- and twelfth-century castles, was more resistant to attack, but sheer strength was not enough. Despite its formidable appearance there was a weakness — sharp corners, easy to undermine — which prompted the appearance of round tower keeps in the early thirteenth century. By this time a stone curtain wall was also being constructed round the site, not only as extra protection for the keep but also to offer defenders a wider field of fire.

Opposite page: A spirited attack on a city, c.1400. Stowe MS 54, f. 83

Soon defence shifted from the keep and curtain walls were modified accordingly. Built higher to discourage scaling by ladder, they were given towers curved to the field to maximise coverage of the ground beneath. The weakest point of this arrangement, the entrance, was protected by a strong gate-house flanked by high towers and often equipped with a drawbridge and portcullis. Further elaboration produced concentric castles, the culmination of medieval design, where the provision of second, lower curtain walls created a double line of defence and counter-attack, offering a model for the updating of many existing structures through the addition of an outer wall.

Siege warfare utilised a wide variety of skills and weapons. If initial diplomacy failed, an attempt could be made to enter the stronghold and gain control by means of hand-to-hand encounters. The image opposite shows one method of achieving this, an assault by a scaling party using tall ladders. Highly effective if well supported by covering fire, escalade was also an extremely dangerous activity as

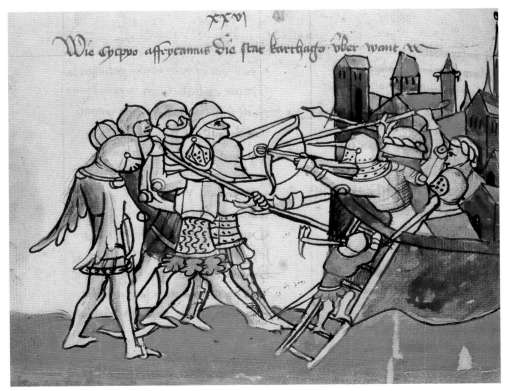

A defender in a siege applies the power and accuracy of a crossbow, fifteenth century. Add MS 11616, f. 34v.

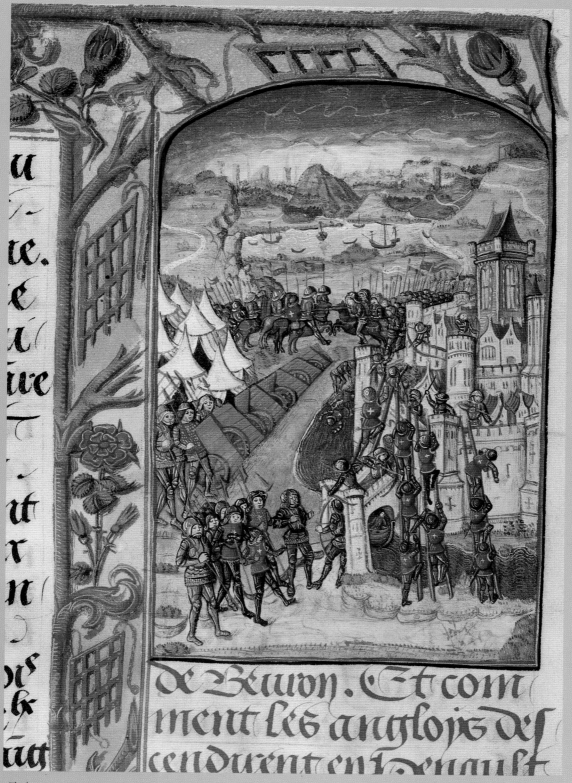

The besieging army protects its encampment, 1487. Royal MS 20 EVI, f. 20

defenders could dislodge the ladders or hurl down stones or other heavy missiles. The figure scaling the wall in below is Bertrand Duguesclin, a fourteenth-century French knight whose courageous deeds earned him legendary fame. The accompanying account of his life reports that at one siege he fell some considerable distance into the moat when knocked from his ladder by a descending stone. Although lucky enough to survive, his image was almost certainly ruined when he had to be dragged out unceremoniously by his heels.

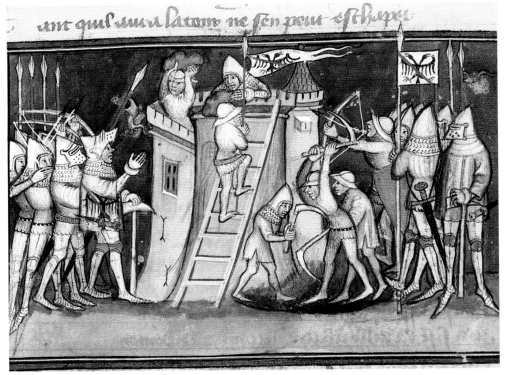

Diplomacy, escalade and mining at a siege, c. 1400. Yates Thompson MS 35, f. 62

The diversion created by the escalade opposite provides cover for a sapper, otherwise unprotected as he breaches the base of the castle wall, while on page 48 sappers carry out their work under cover of a movable shelter. An initial breach either preceded further destruction with a ram or was the first stage in undermining the foundations of the castle, an operation greatly feared by defenders because it was virtually impossible to counter (see page 49). At a point where the structure was most vulnerable a cavity was hollowed out in the base of the wall, underpinned with

wooden stays to avoid premature collapse and packed with combustible material. When this was ignited the stays caught fire and collapsed, bringing down the wall above. Such mining activity was sometimes concealed by starting operations under cover at a distance from the wall and tunnelling under the foundations. Defenders were totally helpless against such an attack, unless they could manage to dig a countermine and gain access to the besiegers' tunnel for a hand-to-hand engagement.

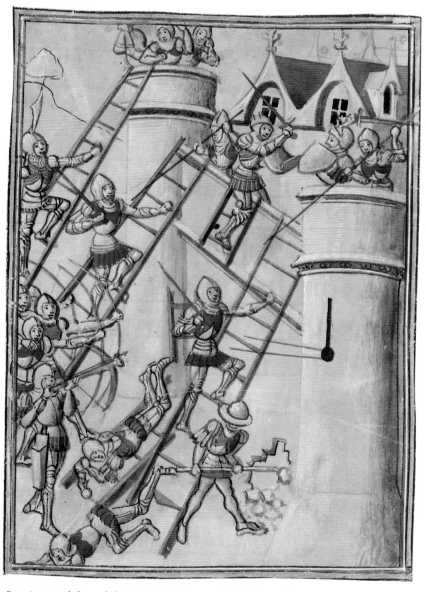

Storming a castle by escalade, 1468-1475. Burney MS 169, f. 174v.

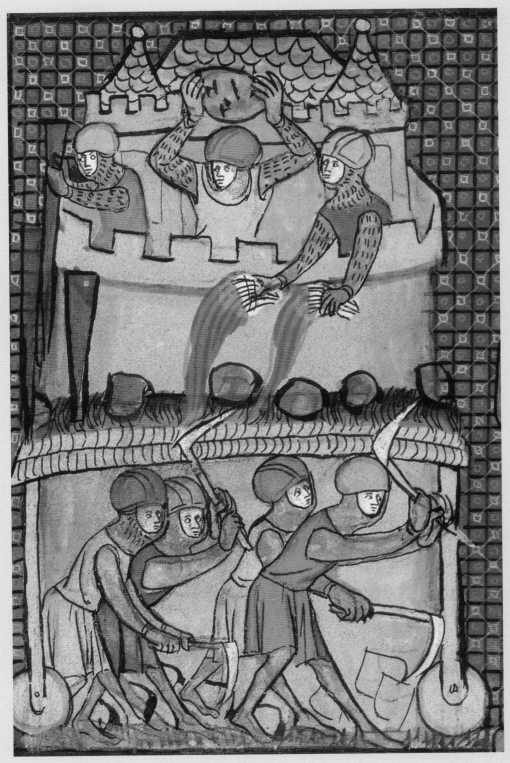

Mining under cover of a movable shelter, 1325–1350. Royal 16 G VI, f. 74.

Scaling, mining and other attempts to gain entry might be successful in their own right, but a castle could also be surrounded and attacked by means of bombardment. Arrows were useless against stone masonry so huge engines, derived from those of classical antiquity, attacked the stonework and intimidated defenders by hurling dangerous or unpleasant missiles into the besieged area. Earlier machines, very rarely illustrated in manuscripts, were either a kind of giant crossbow relying on

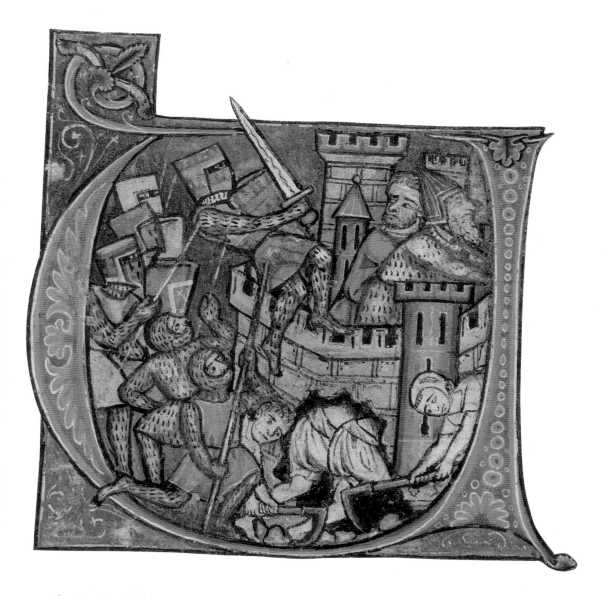

Undermining the walls of a city, c. 1250–1260. Yates Thompson MS 12, f. 40v.

the principle of tension for propelling its missile, or a sort of catapult, sometimes identified as a mangonel. This was a wooden frame with a twisted skein of springy material stretched between its sides, through which was inserted a revolving arm with a hollow at one end for the projectile. The missile-carrying end of the beam was winched down and released, the twisting action of the skein bringing about the firing of the missile.

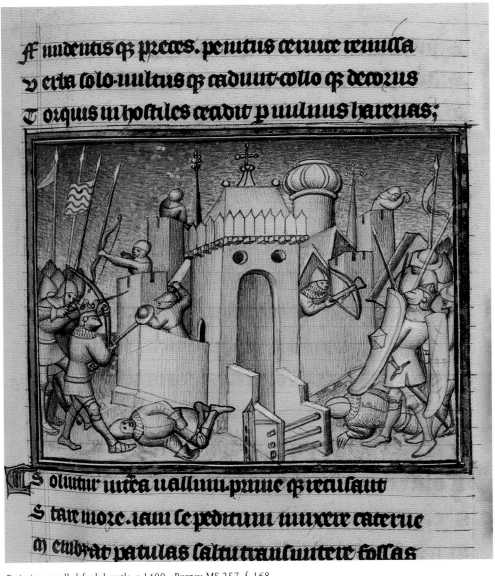

Besieging a well-defended castle, c.1400. Burney MS 257, f. 168

The third type of machine, a medieval invention simpler than its earlier counterparts and more powerful, worked on the pivot principle. The trebuchet, portrayed in a remarkably detailed and convincing way in an amusing marginal

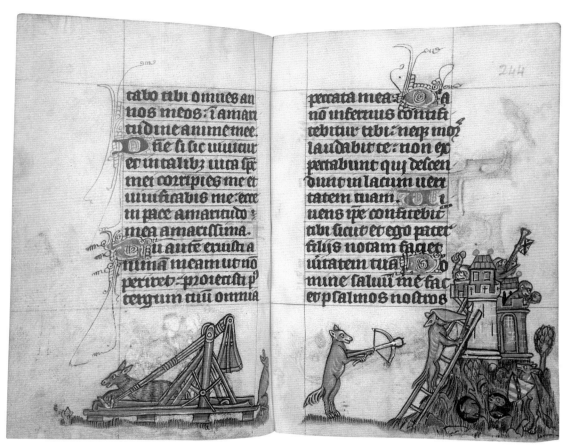

Operating a trebuchet, c.1300. Stowe MS 17,ff. 243v-244.

drawing in a Book of Hours (above) had a sling at the longer end of the arm, while a box containing a heavy weight was attached at the other end. Thanks to the force of gravity the counterweight dropped when released, causing the arm to revolve and the sling to be tossed outwards and upwards to discharge its projectile, a process demonstrated on page 52 (top), where two trebuchets are shown in action. This miniature also suggests the massive size of the trebuchet, generally much larger than earlier stone-throwing machines, and with a longer range.

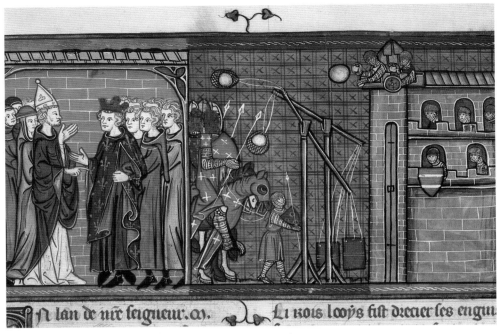

Two trebuchets in action at a siege, 1325-1350. Royal MS 16 G VI, f. 388

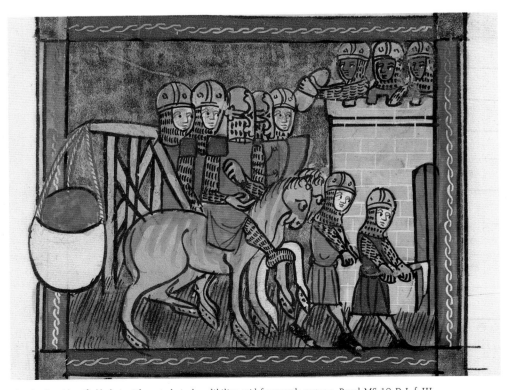

A trebuchet, identifiable but with no technical credibility, mid fourteenth century. Royal MS 19 D I, f. III

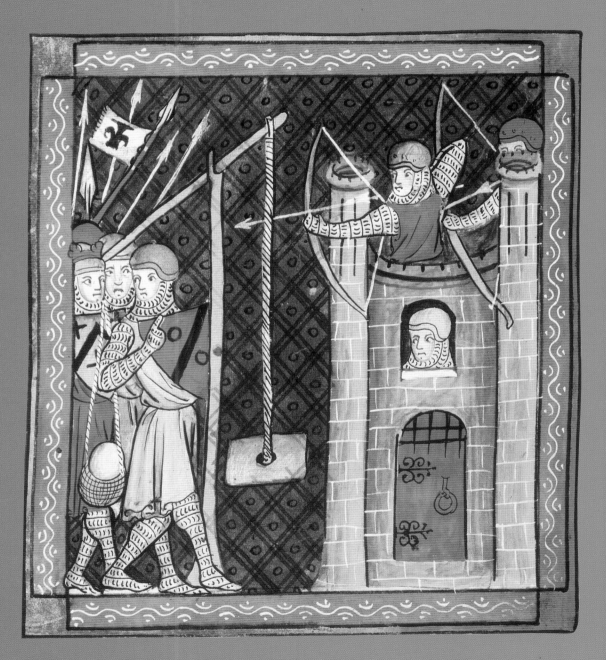

A trebuchet in use at a siege, 1325-1350. Royal MS 16 G VI, f. 345v

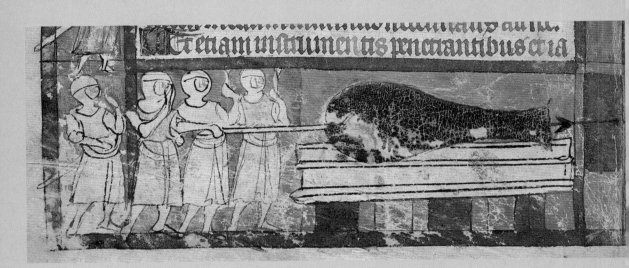

Firing the earliest known cannon, 1326-1327. *Add. MS 47680, f. 44v.*

GUNPOWDER AND THE DECLINE
OF MEDIEVAL WARFARE

The innovation responsible for challenging and finally transforming medieval warfare practices was gunpowder, which opened up the way for new, more powerful types of weapon, capable of achieving a far more devastating impact than that of their traditional counterparts. Thought to exist in the thirteenth century, there is no evidence of the exploitation of gunpowder for warfare purposes until about the mid-1320s. A reference to a cannon appears in the ordinances for the city of Florence of 1326, and the first known pictorial representations occur at about the same time. An illustration in a manuscript in the library of Christ Church, Oxford, has achieved international fame as the earliest surviving picture of a cannon. This volume, a treatise on the duties and obligations of a king by Walter of Milemete, King's Clerk and later Fellow of King's Hall, Cambridge, is one of a pair of manuscripts executed in 1326-1327 and intended for presentation to Edward III. Its companion, a treatise on the education and duties of princes attributed to Aristotle, contains a similar representation of a cannon (opposite). This shows a primitive, vase-shaped gun, lying on a massive frame and loaded with a long-headed dart. Four figures are in attendance, one of whom ignites the weapon through a touch hole at the rear or breech end, level with the mouth. The artist must have been unaware of the cords needed to lash the gun to the frame – the force of the explosion would almost certainly have caused a free-standing gun to recoil, killing both gunner and bystanders.

The unusual 'bottle' shape of this cannon probably ensured that the section where the gunpowder actually exploded was the strongest part of the weapon. A very early vase-shaped gun found in Sweden indicates that the barrel inside was cylindrical as in a modern gun. The earliest cannon, cast in brass or copper, fired feathered darts or quarrels, but rapid improvements in size and shape soon led to

the use of heavier and more damaging projectiles made of lead and stone. Towards the end of the fourteenth century, when the 'bottle' shape had been replaced by a cylindrical form with one end closed by an iron chamber for the powder, cannon started to be constructed from longitudinal strips of iron welded together, with iron hoops driven over them from end to end. Many early cannon were comparatively small like the early fifteenth-century piece on page 37, which has a complex shape consisting of a short thick barrel and a rather longer and narrower chamber with a broader rim at the rear end. Again the artist does not seem to have understood the workings of a cannon – it is apparently firing a stone missile without the aid of an attendant gunner and without emitting any smoke – but the portrayal of the weapon itself may well be based on accurate details, as two similar guns from Italy have survived.

Although often fired directly from ground level, supported by timber framing at the sides with a wooden support let into the ground at the breech end to prevent recoil, early cannon could also be positioned on wooden stands to which they were secured by means of leather thongs, ropes, strong wire or iron bands. The same small piece described above is mounted in this way. It lies in a shaped bed on a stout horizontal wooden beam mounted on vertical and diagonal supports, to which it is fastened with a metal strap passing over the chamber towards the rear end, presumably nailed down to keep it secure. At the rear the narrower part of the beam passes between two parallel wooden bars tilting backwards, possibly acting as some kind of primitive elevating device. Two larger cannon shown in the foreground of a late fifteenth-century siege illustration opposite are similarly mounted on stout platforms at the forward ends of horizontal beams, although in neither case are straps or fastenings visible. Each horizontal beam is supported by a sturdy wooden frame, and the presence of what is apparently an elevating device at the rear of the nearer cannon suggests that the beam may pivot on the frame to improve the range. Elevating quadrants used with

Opposite page: The devastating effect of cannon-fire on a city, 1468-1475. Burney MS 169, f. 21v.

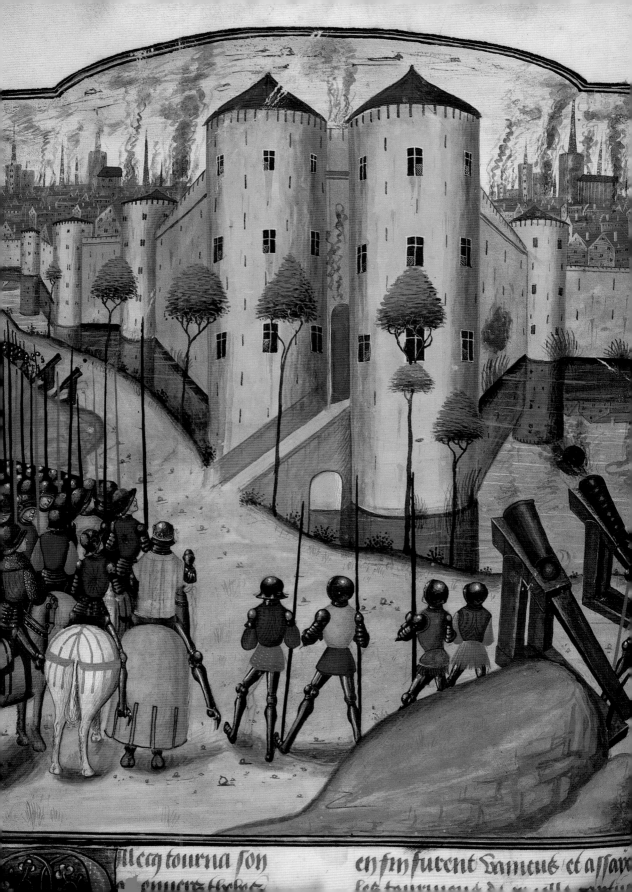

Illeq tourna son en fin furent Vamcus et affa

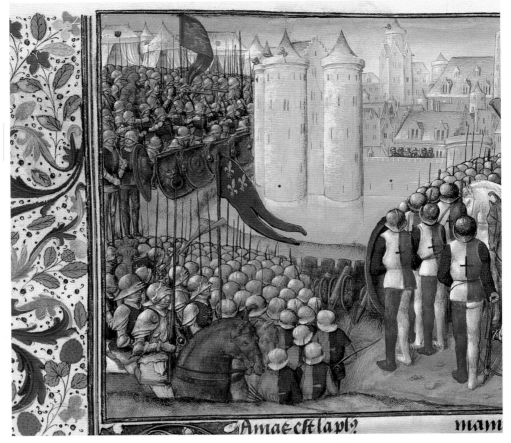

Siege with mobile cannon and musicians, late fifteenth century. Royal MS 15 E I, f. 280v.

such supports normally took the form of a curved wooden or iron upright with a number of holes to take a securing pin which enabled the end of the support for the gun to be secured at the desired angle. Cannon used on fixed stationary supports like those illustrated would have been awkward to transport, so it is hardly surprising that wheeled gun carriages soon made an appearance and became widely used (above).

Beside the cannon shown in the illustration opposite we see armed figures equipped with handguns, another development arising from the use of gunpowder. First appearing in the later part of the fourteenth century they were conceived as a kind of miniature cannon with a long wooden handle attached to a short brass barrel. The gunners in the illustration are firing with their guns held under their

Opposite page: Handguns in use at a siege, 1468-1475. Burney MS 169, f. 127.

nent alexandre passa la montaigne R ontre a son ost a mesmes ce
cancase de la satiation dicelle et qui suiuir ne pouoiet paruedict je
la cite dalexandrie quil y fonda. ix. a lassamblee.

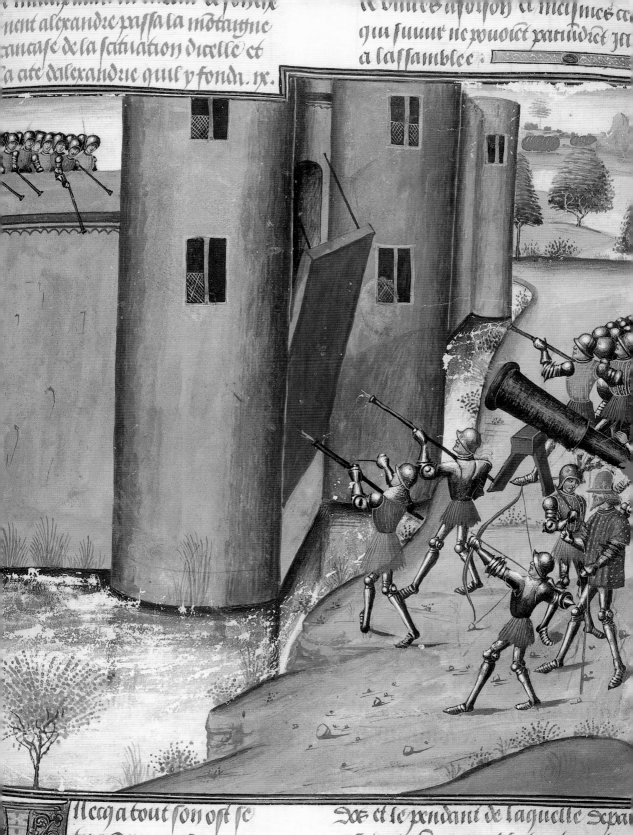

Il ce a a tout son ost se Des et le pendant de laquelle se pa
tira deueurs la mon asse par huy comble tout continue
taigne de cancase le et joinct essamble. Dun coste re ya

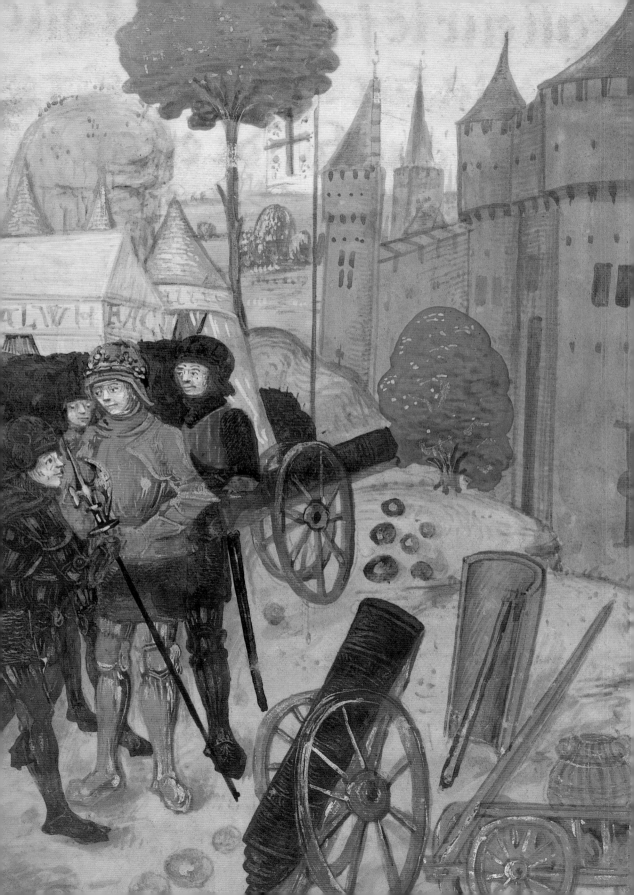

arms, but sometimes they were rested on the shoulder for taking aim. One of the gunners appears to be firing his weapon through a touch hole at the top of the barrel, using a piece of burning slow-match held in his hand. Handguns were commonly fired either in this way or with a piece of wire, red-hot at one end.

Although as a propelling agent gunpowder was far superior to the forces of tension, twisting and gravity on which the firing of traditional weapons had relied, neither cannon nor handgun achieved the instant success that might have been expected, taking quite some time to become established as serious rivals to the weapons that they finally displaced. In hindsight this is hardly surprising as the handling of gunpowder must have been extremely dangerous in the early days. Primitive cannon were not only inaccurate to fire and cumbersome to move and manoeuvre, but also highly unsafe in themselves because they were liable to fracture and burst. James II of Scotland met his death during the successful siege of Roxburgh in 1460, not as a result of enemy action but from the effects of an exploding siege cannon. Contemporary accounts vary in their description of the exact circumstances, but one reports that the cannon was merely being prepared to fire a welcoming salute to his queen, Mary of Guelders, who was due to arrive during a pause in the proceedings.

Despite its early problems, the introduction of gunpowder signalled the beginning of the end for traditional medieval warfare. Although typical medieval weapons continued in parallel with their gunpowder-fired counterparts for quite some time, the advantages of exploiting the superior power of gunpowder soon became apparent as the necessary technology developed to construct cannon and handguns that were both safer to operate and more powerful in their effect. The gradual take-over of these new weapons of combat not only gave a fresh dimension to traditional military encounters, but also introduced a mechanical and impersonal element to combat that was ultimately to bring about a complete change to the face of warfare as it had been known in the Middle Ages.

Opposite page: Cannon and accoutrements, late fifteenth century. Royal MS 15 E I, f. 209.

FURTHER READING

R. Barber
The Knight and Chivalry rev. ed., 1995

C. Gravett
Knights at Tournament, 1988
(Osprey Elite Series, no. 17)

M . Prestwich
Armies and Warfare in the Middle Ages, the English Experience, 1996

R.Hardy
Longbow, 1976.

J. Bradbury,
The Medieval Archer, 1985.

C. Gravett
Medieval Siege Warfare, 1990
(Osprey Elite Series, no. 28)

J. Bradbury
Medieval Siege, 1992

Individual volumes of the Osprey 'Men-at-arms' series, especially:
T. Wise
Medieval European Armies, 1975

C. Rothero
The Armies of Crecy and Poitiers, 1981

T. Wise
Medieval Heraldry, 1980

Warfare illustrations appear in a wide variety of manuscripts dealing with very diverse subjects. The illustrations for this book were taken from the following:-

Add. MS 11616. Das Schachzabelbuch, translation of a Latin allegorical treatise on chess. Germany, fifteenth century.

Add. MS 12228. Romance of Meliadus in French. Naples, c. 1352.

Add. MS 15276. Copy of an eleventh-century Greek manuscript of Hero of Byzantium's treatise on siege warfare. Italy, sixteenth century.

Add. MS 23145. Book of Hours. France, late fourteenth century.

Add. MS 39645. Flavius Josephus, De Bello Judaico. Germany, twelfth-thirteenth century.

Add. MS 44985. Fragment of the *Strategemata* of Frontinus. Italy, late fourteenth century.

Add. MS 47680. Treatise attributed to Aristotle on the education and duties of princes, made for presentation to Edward III. England, 1326-1327.

Add. MS 47682. The Holkham Bible Picture Book. England, c. 1327-1335.

Burney MS 169. French translation of a life of Alexander the Great by Quintus Curtius Rufus. Flanders, 1468-1475.

Burney MS 257. The Thebais of Statius, in Latin. France, c. 1400.

Cotton MS Nero D ix. Romance of Jehan de Saintrè. France, c. 1470.

Cotton MS Nero E ii. Les Grandes Chroniques de France. France, c. 1415.

Eg. MS 1500. Summary of Universal History, from the beginning of the world to 1314. Written in a Provençal dialect, early fourteenth century.

Harley MS 326. Romance entitled 'The Three Kings' Sons'. England, c.1480.

Harley MS 1319. Life of Richard II. France, early fifteenth century.

Harley MS 4389. Prose 'Tristan' in French. Naples, c. 1300.

Harley MS 4418. Romance of Mélusine. France, fifteenth century.

Harley MS 4431. Works of Christine de Pisan. France, early fifteenth century.

Harley MS 4751. Bestiary. England, 1230-1240.

King's MS 5. Biblia Pauperum. Netherlands, c.1405.

Lansdowne MS 782. Chanson d'Aspremont, romance relating to the wars of Charlemagne in Italy. France, 1225-1250.

Royal MS 2 B VII. Queen Mary Psalter. England, early fourteenth century.

Royal MS 14 E IV. Chronicle of England, by Jean de Waurin. Flanders, late fifteenth century.

Royal MS 15 D VI. Livy's History of Rome. France, end of the fourteenth century.

Royal MS 15 E I. French translation of William of Tyre's History of the Crusades. Flanders, late fifteenth century.

Royal MS 15 E VI. Poems and romances, made as a gift for Margaret of Anjou, Queen of Henry VI. France, 1445.

Royal MS 16 G VI. Les Grandes Chroniques de France. France, 1325-1350.

Royal MS 16 G VIII. Caesar's Commentaries, in French translation. Flanders, 1473,

Royal MS 16 G IX. French translation of Xenophon's Cyropaedeia (History of Cyrus of Persia). Flanders. c.1470-1480.

Royal MS 19 D I. Romances and accounts of travel, including the voyages of Marco Polo. France. mid fourteenth century.

Royal MS 19 E II. 'Perceforest' or 'Anciennes Chroniques de la Grande Bretagne'. Flanders, late fifteenth century.

Royal MS 20 A II. Chronicle of England in French verse by Peter of Langtoft. England, 1300-1325.

Royal MS 20 B XI. Vegetius, De re militari. France, early fourteenth century.

Royal MS 20 E VI. Les Grandes Chroniques de France, made for Sir Thomas Thwaytes, Treasurer of Calais, as a gift for Henry VII. Written in Calais, 1487.

Stowe MS 17. Book of Hours. Maastricht, c.1300.

Stowe MS 54. Universal Ancient History from Laius of Thebes to BC 60. Illuminated in Paris by a Netherlandish artist, c.1400.

Yates Thompson MS 12. Translation of William of Tyre's History of the Crusades. France, c. a1250-1260.

Yates Thompson MS 32. Chronicle of the Kings and Dukes of Burgundy. Flanders, c.1500

Yates Thompson MS 33. Chronicle of the Dukes of Normandy. France, late fifteenth century.

Yates Thompson MS 35. Life of Bertrand Duguesclin in verse. France, c.1400.

INDEX

THE AUTHOR

Pamela Porter is Curator of German and Scandinavian Manuscripts at the British Library and was the organiser of the exhibition 'Knyghthode & Batayle: Medieval Warfare through the Ages' in 1993.

Illustration facing title page: A well-painted and convincing battle scene, c.1470. Cotton MS Nero D ix, f. 77v.

Published in North America in 2000 by
University of Toronto Press Incorporated
Toronto and Buffalo

Canadian Cataloguing in Publication Data
Porter, Pamela (Pamela J.)
 Medieval warfare in manuscripts

(The medieval world in manuscripts)
Co-published by the British Library.
ISBN 0-8020-8400-1

1. Illumination of books and manuscripts, Medieval. 2. Military art and science – History – Medieval, 500-1500. 3. Military art and science in art. I. British Library. II. Title. III. Series: Medieval world in manuscripts.

ND2920.P67 2000 745.6'7'0902 C00-931113-0

First published in Great Britain by
The British Library
96 Euston Road
London NW1 2DB

Designed and typeset by Crayon Design, Stoke Row, Henley-on-Thames
Colour origination by Crayon Design and South Sea International Press
Printed in Hong Kong by South Sea International Press